BLACK AMERICA SERIES

HERTFORD COUNTY
NORTH CAROLINA

Jim Flood's general merchandise store was located on Murfreesboro's East Main Street in the 1940s. In the 1960s, it was demolished to build NC Highway 11. Pictured are Louise Flood Fleetwood and unidentified relatives. The store appears to be a rare two-story shotgun house most often found in New Orleans and the deep South. (Courtesy of Constance Marie Boyce.)

BLACK AMERICA SERIES

HERTFORD COUNTY
NORTH CAROLINA

Alice Eley Jones

Copyright © 2002 by Alice Eley Jones.
ISBN 0-7385-1481-0

Published by Arcadia Publishing,
an imprint of Tempus Publishing, Inc.
2 Cumberland Street
Charleston, SC 29401

Printed in Great Britain.

Library of Congress Catalog Card Number: 2002112404

For all general information contact Arcadia Publishing at:
Telephone 843-853-2070
Fax 843-853-0044
E-Mail sales@arcadiapublishing.com

For customer service and orders:
Toll-Free 1-888-313-2665

Visit us on the internet at http://www.arcadiapublishing.com

This book is dedicated to Mr. and Mrs. Fred D. Eley Sr., Minnie Perkins,

Troy Eley, and Mr. and Mrs. Percy L. Hall.

Contents

Acknowledgments		6
Introduction		7
1.	Traditional Meherrin Folkways	9
2.	Madge Watford Hunter	17
3.	Free People of Color	25
4.	Enslaved Africans and Southern Folk Culture	33
5.	Builders and Artisans	53
6.	Troubled Waters	63
7.	Calvin Scott Brown	75
8.	Robert Lee Vann	87
9.	Education and Religion	95
10.	Parting Shots	113

ACKNOWLEDGMENTS

For encouragement, assistance, and patience, the author wishes to thank Otelia Artis Perry; Veronica Hill; Cynthia Williams; Bruce Bridges; Ann Eley Riddick; April Eley Jackson; Annie Vaughan Felton; Howard J. Hunter Jr.; Benjamin F. Speller Jr., North Carolina Central University; George Stevenson, North Carolina Division Archives and History; Dudley E. Flood, UNC—Board of Governors; Thomas Parramore, Historic Murfreesboro Commission; Chicago artist Wilbur Homer Rouson; California artist Kadir Nelson; Durham architect Jason Layne; Myrick Howard, Preservation/North Carolina; Elizabeth F. Buford, Deputy Secretary North Carolina Department of Cultural Resources; Calvin R. Bryant of the *Roanoke Chowan News Herald;* Joe Hall; and Laura Daniels New of Arcadia Publishing.

From left to right are students Maria Felton, Brenda Brooks, Ruby Gatling, Shirley Stephenson, Gladys Peebles, Carolyn Cooper, and Melvin Porter, as they gather between classes at C.S. Brown High School in 1965. (Courtesy of Dudley E. Flood.)

INTRODUCTION

At the occasion of its creation in 1759 from Chowan, Bertie, and Northampton Counties, Hertford County and northeastern North Carolina had been the permanent home of blacks for 173 years. England's Sir Francis Drake inadvertently furnished North Carolina with its first black inhabitants in the late 1500s. Drake raided Spanish-held islands in the West Indies in 1585 and 1586 and acquired numerous prisoners, including Moorish (North-African) galley slaves and soldiers, a group of enslaved Africans (to whom he promised their freedom), and approximately 300 native South Americans. Drake then sailed to Roanoke Island to relieve the Ralph Lane colony. Departing Roanoke Island for England in June 1586, Drake freed the South American and African captives, although he kept the Moorish prisoners. The South American and African captives probably melted into the local Native American population preceding the first permanent English settlers in the region by nearly 70 years.

Permanent English settlement of the area is attributed to Nathanial Batts of Virginia in the 1650s. The Chowan, Meherrin, and the Wiccacon Rivers served all who originally dwelled here and those who came to live in the heavily forested, bountiful waterscape. By 1663 the number of settlers in the Albemarle region exceeded 500, and some of this number may have been enslaved Africans. The vast majority of the newcomers were Virginians who entered under the headright system, which allowed 50 acres of land for every person (including slaves) brought into the colony, and contained a large independent artisan class. With these artisans came wealthy mariners and merchants.

The 356 square miles that would ultimately contain Hertford County witnessed slaves listed on a census as early as 1720 living in the vicinity of Potecasi Creek. These included "a [N]egro man named Weakom," who was a servant of Robert Patterson, and "a [N]egro man of Anthoney Lewises called Pettr." A census in 1757 for tax purposes gives the names of Tom, belonging to Henry Copeland; Ned and Judy, who belonged to Leonard Langston; Luke Langton's Joe; and Charles Jenkins' Bevis, Doll, Bridget, and Phillis. Other names of slaves on the list were Cork, Punch, Daniel, Primus, Sharper, Tom, Peter, Sip, Lock, Celia, Luce, Teresa, Pat, Quash (an African name), Ginney, Bridget, Kale, Nann, Teague, Priss, Moll, Rose, Pompey, Lucinda, and many others. On John Campbell's Petty Shore farm lived slaves Jack, Cambridge, Dick, Obbah, Jone, Winneco, Dinah, and Lucinda. Perhaps, they are the ancestors of some of today's Hertford County residents.

In Hertford County, the African, English, and Meherrin civilizations that had developed separately contained several basic characteristics in common, which contributed to the work ethic required to create and sustain prosperity. All had political structures governing their secular affairs, kinship customs regulating their social life, economic systems defining their modes of subsistence, and one or more sets of indigenous religious beliefs. They all organized their work

assignments on the basis of the sexual division of labor. Men and women performed different tasks, although the specific definitions of those tasks varied from culture to culture.

The vast majority of captured West Africans were farmers who hailed from a broad based culture of West-African languages, religion, arts, architecture, folk medicine, food ways, folkways, dance, animal husbandry, music, and science. By 1860 more than half of Hertford County's population was black. The large number of blacks (slave, free, and mixed) concentrated in the county had a profound effect on whites and the surviving Meherrin population as well. For example, housing styles were more African than English or Meherrin. Farms and plantations evolved with clusters of small buildings—serving as kitchens, dairies, storage sheds, spinning rooms, corn cribs, and smoke houses—taking the place of one large structure encompassing all those functions. The climate, waterways, and landscape of northeastern North Carolina made possible the introduction of African boat building, fishing, architecture, and farming practices in Hertford County.

Africans encountered a world that depended upon their labor but had little respect for their cultural traditions. As a result the African-American experience has often been misinterpreted, their historical significance obscured. Their stories in their words is the theme of this book.

Unidentified students pose at Waters Training School in 1928. The center girl, front row, may be Madge Watford Hunter. (Courtesy of Howard J. Hunter Jr.)

One
Traditional Meherrin Folkways

In 1726, due to encroachment in Virginia, the Meherrin people migrated south from Virginia into Hertford County and established themselves at the former Ramoushanouk Indian Reservation at the mouth of the Meherrin River, now called Parker's Ferry in Mapleton. Hunters, fishermen, and farmers, they also served as guides into the interior of Hertford County for enslaved African and English pioneers. Over time, the Meherrins intermarried with the Chowan Native Americans of neighboring Gates County, as well as African and English settlers. Present-day descendants include the Robbins of Gates County, who were recognized as Chowans and were large landowners and skilled artisans before the Civil War. The Collins were listed as Indian on the 1900 Hertford County census while the Pierce name is associated with the Mattamuskeet people. Since 1924, all Native Americans born within territorial limits of the United States have been considered United States citizens. Before that time, Native Americans in North Carolina and Hertford were generally listed as "mulatto."

Dance ceremonies remain an important part of Meherrin cultural expression as demonstrated at a contemporary Hertford County Pow-Wow. (Courtesy of *Roanoke Chowan News Herald*.)

The Meherrin used all that they found in nature and wasted very few natural resources. They used animal bones as needles, plant fibers, and vines for baskets, and they sewed deerskin garments using thread made from deer sinew. They tanned deer hides for clothing and fashioned homes, canoes, drums and flutes from trees. (Courtesy of *Roanoke Chowan News Herald*.)

Arrowheads, deer antlers, bones, and rocks were used in hunting and in the home. (Courtesy of *Roanoke Chowan News Herald*.)

A Meherrin demonstrates the art of rope making using plant fibers. (Courtesy of *Roanoke Chowan News Herald*.)

This is an exhibit of tanned deer hides used by the Meherrin for clothing. (Courtesy of *Roanoke Chowan News Herald*.)

These baskets, woven mats, and foods were typical of those found in a Meherrin home. They ate boiled and roasted venison, fish, fruits, squash, corn, and seasoned herbs. They also made wine from local grapes. (Courtesy of *Roanoke Chowan News Herald*.)

Foods were cooked outside by women over an open fire in hand-turned, round-bottomed clay pots resting on small mounds of dirt. The pots were surrounded by wood that distributed the heat evenly in the pot. (Courtesy of *Roanoke Chowan News Herald*.)

Meherrin are pictured building a traditional Hogan (center) or dwelling of logs, vines, and woven mats. (Courtesy of *Roanoke Chowan News Herald*.)

A "hallowed fire" is ignited, in which the Meherrin cast a cured tobacco plant called *uppowoc*, which they also smoked in clay pipes. (Courtesy of *Roanoke Chowan News Herald*.)

Meherrin descendants gather at an annual Pow-Wow between Murfreesboro and Ahoskie to strengthen their cultural traditions and kinship bonds. (Courtesy of *Roanoke Chowan News Herald*.)

Meherrin children are introduced to ceremonial dance by group elders. Children are encouraged to learn traditional customs at an early age by Meherrin community leaders. The Meherrin people also attend the Meherrin Baptist Church in Winton. (Courtesy of *Roanoke Chowan News Herald*.)

The beauty of traditional Meherrin and Native-American clothing is an integral part of all ceremonial dances. Each dance group is given a number when they participate in ceremonial dance competitions. All clothing and headwear is made by family members as a token of cultural pride. (Courtesy of *Roanoke Chowan News Herald*.)

North Carolina representative Howard J. Hunter Jr., a Meherrin descendant, unveils the official highway marker located on Highway 258 near Winton that marks the site of Meherrin Town in a 1995 ceremony. (Courtesy of *Roanoke Chowan News Herald*.)

Sallie M. Lewis (1838–1904), a full-blooded Meherrin, married Elvey D. Lewis (?–1906), "a free person of color," of Union where they owned a large farm and reared seven children. Sallie's family and friends remembered her fondly for her beautiful vegetable and herb gardens. She was skillful in the use of blending herbs for medicinal purposes and poultices for ailing family members and friends. (Courtesy of Cordy Jordon.)

Cordy Jordon, great-great grandson of Sallie and Elvey Lewis, remembers the not-so-distant past when Meherrin people had little or no choice in how they were officially classified as a people. Today, however, Jordon noted that they are free to identify with their Meherrin cultural traditions and are legally recognized as such. Jordon is active in his Winton community and is a member of the C.S. Brown Regional Cultural Arts Center and Museum Board of Directors, also in Winton. (Courtesy of Cordy Jordon.)

Two
MADGE WATFORD HUNTER

Some Meherrins who married whites founded Archer Town in the middle or late 1700s. They were isolated to the point of having their own schools in the late 1800s and early 1900s. Many Archer Town residents identified themselves as Meherrin while others called themselves Cherokee. The Meherrin people who married free blacks lived in the Pleasant Plains community and today their families remain members of the Pleasant Plains Baptist Church. Surnames of Meherrins attending the church in 1851 are Reynolds, Boone, Weaver, Hall, Keene, Reid, Delk, Bizzell, Manley, Wiggins, Lang, Sears, Nickens, Archer, and Chavis.

The grandsons and great-grandsons of Carrie Chavis Bizzell, a Meherrin, pose at a formal gathering. Carrie Chavis Bizzell was the mother of Madge Watford Hunter, who was the mother and grandmother of, from right to left, Howard J. Hunter III, Howard J. Hunter Jr., J. Andrew Hunter, and J. Andrew Hunter II. Madge Watford Hunter lived a very remarkable life almost entirely in and around the Pleasant Plains community where she was born and came of age. She was married to area businessman and community leader Howard J. Hunter Sr. and contributed greatly to her family, community, and Hertford County. (Courtesy of Howard J. Hunter Jr.)

Mr. and Mrs. Watford pose with their children, baby Julius and daughter Madge in this family portrait taken at their home. (Courtesy of Howard J. Hunter Jr.)

Young Madge poses with baby brother Julius for the camera. (Courtesy of Howard J. Hunter Jr.)

Madge and Julius pose on campus. (Courtesy of Howard J. Hunter Jr.)

World War II veteran Howard Hunter Sr. and Madge look every bit the happy couple in this August 1945 pose. They were married later that year in December. (Courtesy of Howard J. Hunter Jr.)

19

In 1989, Hunter was selected as a "Woman of the Century" by the Hertford County Council on the Status of Women. This is just one of the many honors she achieved during her lifetime. She was a graduate of Waters Training School, Virginia State College (Petersburg, Virginia) and Indiana University. In 1965 she was named art supervisor for Hertford County. She was a charter member of the Ahoskie Alumni Chapter of Delta Sigma Theta Sorority, and she was a member of The National Education Association, the North Carolina Association of Education, and the National Art Education Association. She is past president of the Ahoskie Arts Council and past member of the board of directors at Ahoskie's Gallery Theater. Her teaching career spanned some 38 years with several students winning local, regional, and national honors. (Courtesy of Howard J. Hunter Jr.)

In 1976 Hunter selected this drawing by Ahoskie High School senior Ricky Lassiter as the official seal to represent the Hertford County Bicentennial Commission in celebration of the nation's bicentennial. (Courtesy of *Roanoke Chowan News Herald*.)

John Eley Jr., then a Murfreesboro High School senior, was invited to audition for the Governor's School of Art in 1977. He is the son of noted Hertford County musician, John Eley Sr., who enjoys a regional reputation in musical presentations. (Courtesy of *Roanoke Chowan News Herald*.)

North Carolina representative Howard Hunter Jr. snapped this 1977 photo of the United States Capitol Building while attending the inauguration of President Jimmy Carter with the Hunter family. (Courtesy of Howard J. Hunter Jr.)

Howard Hunter Jr. was elected to the North Carolina General Assembly in 1989. He is believed to be the first African American/Meherrin to be elected to public office on the state level. (Courtesy of Howard J. Hunter Jr.)

Thirteen-year-old Julian Hunter, grandson of Madge Hunter, demonstrates his championship dance style with his father J. Andrew Hunter in Washington, D.C. They were attending the 2002 Celebration of Native Americans as special guests of the United States Department of Labor. (Courtesy of Howard J. Hunter Jr.)

Howard J. Hunter III, his son Montario, and other family members traveled to Washington, D.C. in 1998 for the official portrait unveiling ceremony of their uncle and great uncle Mike Espy, former United States Secretary of Agriculture. Espy is the brother of Hunter's mother Laverne Espy Hunter. (Courtesy of Howard J. Hunter Jr.)

Montario Hunter is pictured with Rev. Jesse Jackson and great uncle Mike Espy at the United States Department of Agriculture. (Courtesy of Howard J. Hunter Jr.)

Montario Hunter and President William "Bill" Jefferson Clinton are pictured at the United States Department of Agriculture in Washington, D.C. (Courtesy of Howard J. Hunter Jr.)

Three
FREE PEOPLE OF COLOR

Free people of color probably began immigrating to Hertford County on the heels of wealthy merchants, mariners, artisans, and yeoman farmers from southeastern Virginia. Often portrayed as criminals and threats to the community, free blacks were regulated by prejudice rather than merit, to the rung of society slightly above slaves. The major tenants of slavery revolved around the white supremacy philosophy and teachings of the meek, docile, child-like black who needed the care, discipline, and support of benevolent whites. The presence of free blacks were a clear and present danger to the white supremacists justification of chattel slavery. Hertford County early on had a large population of free people of color. A large number apparently married into Meherrin families and this may explain how so many of them became landowners. Similar surnames appear among Meherrin and free black county residents. The Weaver, Smith, Archer, Rawls, Manley, Bass, Bower, Nickens, Orange, Shewcraft, Bezelle, Wiggins, Hall, Reynolds, and Crow families were artisans, farmers, slave owners, and soldiers.

Wiley Jones and daughter Susan are on the porch of their log cabin home, c. 1850. Jones is the grandfather of Alice Jones Nickens of Winton and legend has it that when Union soldiers landed on his farm during the Civil War, he climbed a tree and rejoiced at the burning of Winton in 1862, North Carolina's first town to be burned during the war. (Courtesy of Alice Jones Nickens.)

Free blacks, slaves, and white yeomen farmers lived in log cabins similar to March Taylor's rustic dwelling, shown in this 1925 photograph taken by Dick McGlaughn outside of Winton. Such cabins were normally built by the men who lived in them and consisted of one or two rooms and chimneys made of sticks and mud. Nails were made by hand and therefore scarce and expensive, so wooden pegs were used instead. Cabins that did not sit on stone or log pilings had dirt floors that, when cured in the African and European tradition, produced a hard surface free of dust. Windows were optional because most Southerners in early America believed that the night air posed health hazards. (Courtesy of Thomas Parramore.)

Alice Jones Nickens (right) of Winton, granddaughter of Wiley Jones, accepts a preservation plaque for her years of service to Hertford County. (Courtesy of *Roanoke Chowan News Herald*.)

From its earliest days, Hertford County had an almost desperate need for tanners (pictured), coopers, builders, and others. To meet the ever-increasing need for skilled labor, North Carolina as early as 1733 enacted legislation that required free black children to be bound out as apprentices. This practice more or less guaranteed that free black children would learn to read, write, and do simple arithmetic. A legal requirement of the apprentice system that spread underground to the slave community. (Courtesy of the author.)

Free black boys had a relatively large number of occupations open to them. The largest number were apprenticed as carpenters or one of the other building trades, seen here. They were also apprenticed as coopers, ship's caulkers, blacksmiths, shoemakers (Shewcraft surname), tanners, bricklayers, wheelwrights, and millers, to name a few. By far the largest number of free black men were common laborers and farmers by 1860 in Hertford County. (Courtesy of Kadir Nelson.)

27

The trades for free black girls were rather limited. Girls could apprentice as cooks in a kitchen similar to the one pictured here. They might also train as house servants, private maids, milliners, bakers, and seamstresses. The best option for free blacks girls was similar to that of free black boys: to open their own establishment after completion of the apprentice period (usually by age 21), because slaveholders apprenticed their slaves to fill their own business and plantation needs. (Courtesy of the author.)

Spinners and weavers were most often employed by plantation owners who did not wish to spare a large female work force from field labor. Slaves were issued clothing twice a year (summer and winter) and slave mistresses were charged with supervising their construction. In many instances slave mistresses cut out the patterns from the cloth because most agreed that slave cutters were too generous in their sizing. In England and New England there arose a profitable cloth manufacturing industry that specialized in cloth to be used primarily in slave clothing. (Courtesy of the author.)

In a 1937 Raleigh interview, former Murfreesboro resident Anthony Ransome stated, "We were borned free . . . my paw was a shoemaker and he made a pretty good livin' fer us." Ransome's shop may have appeared similar to the one shown here. Shoemakers also made horse harnesses and other leather goods. (Courtesy of the author.)

By 1830, Meede Melton (2), Penelope Mandley (1), Jaston Renalds (2), Lewis Jordon (3), David Roberts (2), Jeston Renalds (1), and David Boon (1) were listed in census records as free black slave owners living in the Pleasant Plains community. The number beside their names indicates the number of slaves held by them. By 1851 free blacks in the same community purchased land to build a church with the understanding from Winton area whites that unsupervised slaves would not be allowed to worship. North Carolina law required slaves to be supervised even in church. The church, pictured here in 1941, was originally called Free Colored Baptist Church but was eventually changed to Pleasant Plains Baptist Church. (Courtesy of Cordy Jordon.)

This is Pleasant Plains Baptist Church as it appeared after being remodeled in 1951. (Courtesy of Cordy Jordon.)

Pleasant Plains Building Committee members stand on the steps of the completed 1951 church remodeling project. From left to right are A.H. Brett, E.M. Weaver, and H.S. Boone, chairman and supervisor of building program. (Courtesy of Cordy Jordon.)

30

The 1951 Pleasant Plains Baptist Church Dedication Committee members, from left to right, are Bessie A. Hall, Samuel James, and Howard J. Hunter Sr. (Courtesy of Cordy Jordon.)

This is the 1951 Pleasant Plains Baptist Church Sunday School. (Courtesy of Cordy Jordon.)

31

Pleasant Plains Baptist Church Senior Choirs pose in front of their newly remodeled church. From left to right are (front row) Mrs. Donnie C. Hall, Mrs. Viola H. Chavis, Mrs. Timmie Weaver, and Mrs. Minnie Reynolds; (middle row) Mrs. Dessie Weaver, Mrs. Daffy Boone, Mrs. Fannie Sawyer, Mrs. Maurice Brett, and Mrs. Cora Chavis; (back row) Howard J. Hunter Sr., E.M. Weaver, H.S. Boone, and H.C. Freeland. (Courtesy of Cordy Jordon.)

Wendell Hall, former assistant superintendent of Hertford County Schools awards certificates at Hertford County Middle School in a 1990s ceremony. Hall's family have long been active members of the Pleasant Plains community and, like Hall, most are citizens of high achievement and community involvement. (Courtesy of *Roanoke Chowan News Herald*.)

Four
ENSLAVED AFRICANS AND SOUTHERN FOLK CULTURE

In 1985, the directors of Historic Williamsburg in Virginia voted to interpret the enslaved African and free black presence at the site. For the first time in the annals of public history, a mainstream historic site endeavored to research, write, and portray the African-American experience from the black perspective. Nearly 20 years later, many local historic sites continue to struggle with this issue. The large population of enslaved Africans in the South and in Hertford County had a profound cultural impact. Black Southern folk belief is strongly influenced by an African pattern of folk belief. There were important parallels in the folk culture of enslaved Africans and the English who held them in bondage. These parallels fostered widespread cultural exchange between the two groups and both groups were enriched. Today Hertford County African Americans have a European folk heritage as well as an African one, and whites have an African folk heritage as well as a European one.

The cabin of Virginian Nathaniel Batts was constructed, perhaps using some slave labor, in early 1654 at the mouth of Salmon Creek on the Bertie County side of the Chowan River and was used by Batts during each fur trading season until 1658. Shortly after 1658, Batts became the first permanent English settler in the Albemarle region. (Courtesy of Jason Layne.)

By 1663, several dozen Virginian families, and perhaps some slaves, settled on the shores of the Albemarle Sound—the beginning of a new colony in North Carolina. Between 1700 and 1725, independent artisans from southeastern Virginia settled in the region that contained numerous swamps, rivers, streams, and creeks. Carpenters, bricklayers, tanners, tarburners, coopers, wheelwrights, blacksmiths, millers, and weavers were eventually joined by members of the wealthy and powerful mariner and merchant classes. Many of these newcomers owned slaves. (Courtesy of *Roanoke Chowan News Herald*.)

A 1720 census lists Weakom, servant of Robert Patterson, and Peter, servant of Anthony Lewis, both in the vicinity of Potecasi Creek. By the late 1750s, there were perhaps 50 enslaved Africans and their families living on small Hertford County farms. (Courtesy of Kadir Nelson.)

Enslaved Africans were brought to America with many well-developed skills and talents that could be put to use on Hertford County waterways. The proliferation of the multiple-log canoe can be regarded as a sign of African-American influence on American water-borne customs. (Courtesy of North Carolina Division Archives and History.)

Hand-hewn logs could be crafted into dugouts as easily as salt boxes for curing meat. Plantation slaves made small boats and skiffs to transport barrels of pork, corn, tar, fish, tanned hides, and shingles to Murfreesboro and Winton to be traded in the West Indies. (Courtesy of the author.)

Coopers were in demand as needs for barrels for shipping naval stores (tar, pitch, and turpentine), corn, pork, beef, salt, and tobacco increased. Their ranks often contained numerous slaves. (Courtesy of Kadir Nelson.)

In 1767, the United States Post Office was established in Winton, a small village containing homes, a tavern, a few shops, a smithy, a courthouse, and a jail. Ocean-going vessels were constructed in Winton and probably relied upon black builders and caulkers. The sawmills and bridges built the previous year in the county were perhaps constructed by slaves as well. (Courtesy of Kadir Nelson.)

Several free blacks served in the Continental Army during the Revolutionary War. Among those from Hertford County were Evans Archer, James Smith, and Moses Manley who served for 18 months with Bailey's company of the Tenth North Carolina Regiment. John Weaver served seven years and received a pension. Hertford County slave owners were on high alert during the war for fear of their slaves running away to fight for the British. (Courtesy of Kadir Nelson.)

In despair, enslaved Africans learned that the democratic ideals of the Revolutionary War did not include their freedoms. By 1790, the Murfree family of Murfreesboro owned 60 slaves while other families owned 30 or more. (Courtesy of Kadir Nelson.)

The 1790 census listed 655 heads of white families. William Rea, a transplanted Boston merchant/mariner, built Rea Store using locally produced brick and perhaps enslaved black artisan labor. By 1803, Rea constructed a one-story addition to the store for his close friend and attorney, Thomas Maney. Today Rea Store remains the oldest commercial structure in North Carolina. (Courtesy of the author.)

Hertford County's economy was driven by slave labor in tobacco cultivation and the naval stores industry. In addition to tobacco and naval stores, the chief exports were lumber, shingles, staves, and headings. (Courtesy of Kadir Nelson.)

Gristmills were important to the county economy and required a court petition before they could be put into operation. Historic Hare's Mill near Winton dates back to the 1740s and was originally owned by Job Rogers and Jonathan Gilbert. Mill owners usually possessed considerable capitol and political clout, and they owned slaves who were trained to become millers. (Courtesy of *Roanoke Chowan News Herald*.)

A gristmill was a symbol of permanence to community members. Hare's Mill rendered a valuable service in grinding wheat and corn for bread and feed for livestock. It was a gathering place and often a local fishing hole. (Courtesy of *Roanoke Chowan News Herald*.)

Seine fishing along the Chowan River at Mount Gallant, Barfields, and Petty Shore was so plentiful by the 1790s that large quantities were exported. Slave men laid and hauled the nets while the women dressed, cut, and salted the fish. (Courtesy of North Carolina Division Archives and History.)

Molasses was the most common sweetener used by slaves and yeomen farmers. Beehives were maintained by plantation slaves for the plantation table. Bell shaped, the hives were usually woven in the traditional coil pattern of West Africa. (Courtesy of the author.)

Horse racing became and remained a favorite pastime along with cockfighting, fishing, and hunting. Most jockeys were slaves. (Courtesy of *Roanoke Chowan News Herald*.)

The care, feeding, grooming, exercise, and riding of racehorses fell to plantation slaves as a specialized form of labor. (Courtesy of *Roanoke Chowan News Herald*.)

Following the Revolutionary War and the loss of British naval stores contracts, trade on the Chowan-Meherrin Rivers began to decline. However, Murfreesboro slaves, depicted to the left, and those in Winton remained active in the growing exportation of tobacco to the West Indies and Europe. (Courtesy of the author.)

Slaves worked as stevedores on the Murfreesboro docks loading hog heads of tobacco aboard ships for exportation to the West Indies (Courtesy of the author.)

Local tradition has it that slaves were unloaded at the dock located behind the tree line on this private farm in the Princeton community near Murfreesboro. (Courtesy of the author.)

As centers of trade with the West Indies, Murfreesboro and Winton were the homes to slave dock workers who were probably privy to the news of the Haitian Revolution and slave conspiracies throughout the South. On the heels of a string of intermittent slave revolts dating back to the 1600s in New York, the 1802 slave conspiracy in neighboring Bertie County was inevitable. Such conspiracies endangered all blacks as whites searched frantically for the guilty parties. (Courtesy of Kadir Nelson.)

Hestia Wynn is pictured in front of her cabin in the old slave quarters of the Wynn family on Murfreesboro's Broad Street. She is named for the Greek goddess of the hearth. Slaves viewed it as an honor for their owners to name their babies. Slave parents regarded the practice as protection against the child being sold. Slave owners went through an early phase of giving slave babies Greek and Roman names. (Courtesy of E. Frank Stephenson.)

Enslaved Africans maintained their cultural traditions in coil basket weaving and carved walking sticks, as well as by creating a West-African stripped quilt–based tradition of sewing strips of Kente cloth together to make blankets and wraps. Following Christian law and tradition, black women covered their heads with bandannas wrapped in creative styles that often denoted their rank. Cornrows and hair wrapped in tobacco twine were also African-based traditions. (Courtesy of the author.)

The distinctive ingredients of Southern cuisine, as well as distinctive styles of cooking them, have been common for centuries in Africa but not in Europe. Sweet potatoes, okra, chicken, fish rolled in cornmeal or batter and deep fried, collards (pictured), and other greens served with pot liquor, black-eyed peas boiled with pork, and varieties of corn bread form the basis of a regional cuisine whose roots are more African than European. (Courtesy of the author.)

Gourds were carved by slaves to make spoons, knives, buttons, water dippers, and water and storage containers. (Courtesy of the author.)

Corn, pork, and salt herring were supplied on a weekly basis and formed the staple diet of Hertford County slaves. Slaves attended lively plantation corn shuckings, and the remaining cornhusks (dry outer leaves) were woven into floor mats and chair bottoms. (Courtesy of the author.)

Cornhusks were also tied to sticks or driven through holes in horizontal boards, attached to handles, and used as mops in combination with lye soap to scrub walls and floors. Cornhusks made practical brushes for applying whitewash to fences, barns, and slave cabins. Traditionally planters had slaves whitewash their cabins just before the Christmas holidays. (Courtesy of the author.)

Drums were outlawed early in North Carolina due to their association with slave conspiracies. Slaves maintained their cultural ties to the drum by creating African-based dances with an African rhythm using their hands and feet. Buck dancing and ham boning demonstrations are performed by folklorists John D. Holman (cap) and Fritz Holloway at Historic Stagville in Durham. (Courtesy of the author.)

The Dismal Swamp Canal, today the oldest surviving man-made waterway in America, was begun in 1793 and stretched from Deep Creek, Virginia to the Pasquotank River. Constructed, maintained, and operated by black men, canal workcamp inhabitants freely shared African-based dance, food ways, architecture, medicine, and music. Similarly, the 1820s slave construction camps of the Buncombe County Turnpike near Asheville produced clogging, the dance so readily associated with mountain culture. (Courtesy of North Carolina Division Archives and History.)

House slaves worked under the supervision of plantation household mistresses and the slave cook. Female domestic slaves included housekeepers, maids, nurses, and dairymaids. They preserved meats and fruits, made hard and soft soaps for plantation use (pictured), sewed, and quilted. They slept in or in close proximity to the plantation house and were usually better fed and better clothed than field hands. House slaves, however, lacked the cultural freedom that field hands enjoyed. (Courtesy of Kadir Nelson.)

Male house slaves, butlers, waiters, and drivers were supervised by the household mistress and the butler or the cook. Most plantation household needs, however, were met by specialized female workers such as candle makers. Harvest season usually brought all plantation slaves together in the fields. House slaves had relatives and friends who lived in the quarters and were never completely isolated from other blacks. (Courtesy of Kadir Nelson.)

Cast-iron cookware was preferred in most Hertford County kitchens for use in open fireplaces. Slaves cooked their meals over open fires in front of their cabins because slave quarters, in ways unknown to whites, were actually small African villages that nurtured African food ways. (Courtesy of the author.)

Plantation kitchens were usually housed in a separate outbuilding away from the main house as a fire deterrent and to avoid kitchen noises and smells. Plantation cooks used the lofts in such kitchens as sleeping quarters for themselves, their helpers, and sometimes their children. The cook sat in the short-legged fireplace chair while frying foods in the three-legged, long-handled, cast-iron "spider" or skillet. (Courtesy of the author.)

Dough bowls (pictured), ladles, breadboards, and buckets—some for home use and more for exporting—were fashioned from swamp cotton or gum trees. A juniper log yielded washing tubs and buckets. Drawing knives were used to make wooden staves for barrels, heading, and shingles. Carpenters were necessary in this trade, and a number of these craftsmen and their slaves were early newcomers to the area. (Courtesy of the author.)

Baked goods were cooked in an oven built in the side of the fireplace in plantation kitchens. Some kitchen chimneys contained compartments inside for smoking meats. Baked goods could also be prepared in a Dutch oven. Slaves made cornmeal "hoe cakes" or "ash cakes" by placing the cornmeal batter on a hoe and setting it among the coals for the bread to cook. (Courtesy of the author.)

Wooden bowls, buckets, tubs, breadboards, dough bowls, cabinets, some slave furniture, shovels, rakes, barrels, and grain storage bins (shown) were crafted on plantations for blacks and whites alike by slave carpenters in the plantation shop. Additional stools, tables, and other wooden cabin household items were built by the slave men. (Courtesy of the author.)

Plantation spinners and weavers produced fabric for clothing as a specialized work task. Before the Revolutionary War, free blacks and slaves wore an imported fabric called "plains." Most travelers noted that slaves in general were either skimpily dressed or nearly naked. Slave children usually wore a shift and were not entitled to a clothing allotment until they began to do the work of "full hands." (Courtesy of the author.)

Plantation food rations were given once a week. Each man was allowed three pounds of salt pork, a peck of corn, and a dozen herring. Women received a pound and a half of meat, a peck of corn, and the same number of herring. Working children over 12 years received half the allowance of the women. Younger children and slaves too old to work did not receive a weekly ration. Slaves cultivated vegetable gardens during their time away from plantation work, and some also hunted and fished. They received fresh pork only at Christmas hog killings, and they received beef only on rare occasions. Some plantations might include molasses in the weekly rations. At night, under the cover of darkness, slaves sometimes raided plantation smokehouses, chicken coops, and storehouses simply because they were hungry. (Courtesy of *Roanoke Chowan News Herald*.)

Five
BUILDERS AND ARTISANS

Crucial to building practices in Hertford County, as throughout the South, were the hundreds of artisans who, as slaves, rarely profited from their labor. Some learned trades informally from other slave artisans, but many were apprenticed to black or white masters by owners who hoped to increase their value for sale or hire. Hertford County slaves may have been sent to Norfolk, Edenton, or New Bern for such training. The popular image of slave artisans focuses on those who worked on their owners' plantation, and certainly this did occur. Other slave artisans worked for owners who were artisans themselves. Many of the leading builders in neighboring cities owned slave artisans and builders. The key to the work of slaves in building was the practice of slave hiring, a system that allowed free North Carolinians to use slave builders when and where they needed them. Slave artisans were hired by the day, month, or year and worked in all the building trades, as sawyers, carpenters, joiners, plasterers, house movers, bricklayers, and painters. Widows and children who inherited slaves; planters, lawyers, mariners, or merchants who did not need their slaves' services at the moment; and men who bought or trained slave craftsmen as investments all profited from slave wages.

Typical of perhaps a slave-built brick house in early Murfreesboro is the *c.* 1820 Morgan-Myrick House built for merchant James Morgan in the historic district on Broad Street. Morgan left Murfreesboro in 1830 for Texas and, some say, owned the beautiful slave Emily Morgan, who inspired the song, *The Yellow Rose of Texas*. (Courtesy of *Roanoke Chowan News Herald*.)

Enslaved Africans contributed several architectural characteristics to Southern buildings, such as steep, sloping hip roofs and porches with a wide overhanging roof. (Courtesy of the author.)

The porch as an architectural component may have entered colonial Hertford County by way of trading with the West Indies. English and European architecture worked very well in northern locales but the heat and humidity of the South was relieved by structures that incorporated West-African architectural characteristics commonly found in West Indian buildings. (Courtesy of *Roanoke Chowan News Herald*.)

Following the Haitian Revolution of 1803, hundreds of free people of color poured into New Orleans, Louisiana, and a smaller group landed in Petersburg, Virginia. Closely on the heels of Haitian immigrants into the South, shotgun houses soon followed. In terms of form, this style breaks a major convention of American folk housing—its gable side, rather than its long side, faces the street, as seen in this unidentified Ahoskie shotgun house. (Courtesy of the author.)

From Senegal all along the Guinea Coast and down the western coast of Central Africa, there stretches a zone with remarkable architectural consistencies. The rectangular, gable-roofed dwelling is constantly identified with this rain forest environment. The row of the now-demolished Diamond Street shotgun houses in Murfreesboro represent these African architectural consistencies. (Courtesy of Ann Eley Riddick.)

The Roberts-Vaughan House of Murfreesboro was perhaps built all or in part by slave artisans. It was built before 1814 by Benjamin Roberts. Around 1835, it became the property of Col. Uriah Vaughan, a wealthy merchant, who added to the four-room house and gave it its present Greek Revival appearance. All original woodwork including doors, mantels, wainscoting, and floors are intact. Several of the original out buildings remain. (Courtesy of Murfreesboro Historical Association.)

Fish scale shingles are shown atop the roof of the Roberts-Vaughan House. Shingles were fashioned almost exclusively by slaves who worked and lived in shingle-making camps in the Dismal Swamp. Cypress trees yielded the most highly regarded shingles, and they were expensive. Shingle roofing was yet another skill in which slave builders excelled. (Courtesy of Murfreesboro Historical Association.)

Contractor Albert Gamaliel Jones of Warren County signed the building contract in 1852 with the building committee of the Wesleyan Female Academy. The boom in big academy buildings sponsored by private or denominational groups seems to have been an especially high-risk area for contractors. Jones, like the Murfreesboro planters and merchants with whom he signed the contract, relied on slave laborers and artisans and free journeymen. This building was destroyed by fire in 1877. (Courtesy of Murfreesboro Historical Association.)

Murfreesboro's Chowan College was founded in 1848 as the Baptist Female Institute. The administration building, "the Columns" was erected in 1851 of locally made bricks. In the tradition of Old East at the University of North Carolina at Chapel Hill, the building and the bricks were probably slave made. (Courtesy of Murfreesboro Historical Association.)

The interior of slave cabins were sparsely furnished with slave-made tables, chairs, stools, or benches. Slaves often slept on piles of rags on the floor or pallets stuffed with grass, pine straw, or hay. Some slave men did craft crude beds but they were important symbols of wealth and considered extravagant for slaves as well as poor whites. (Courtesy of the author.)

These slave cabins were once "the quarters" on the Wynn Plantation located in the vicinity of the Murfreesboro Jail on Broad Street. Slaves built their cabins to plantation owner specifications, with very narrow or no windows. Barely visible are the brick chimneys made of local, probably sun-dried, bricks. Brick chimneys prevented fires in the crowded slave quarters. Some of these slave cabins were still standing in 1950s Murfreesboro. (Courtesy of E. Frank Stephenson.)

Jacob Holt of Warrenton contracted to build the 1874-1875 David A. Barnes House in Murfreesboro. Before the Civil War, Holt's Warrenton shop was the largest in the state and included both slave and free builders. He evidently hired slaves from their owners and boarded nearly 40 male slaves of working age in his household, including at least one bricklayer, Corbin Boyd, whose expertise in chimney building earned him an outstanding local reputation. (Courtesy of Murfreesboro Historical Association.)

This Victorian gate is in the rear entry to the home of former Murfreesboro mayor W.W. "Billy" Hill. The intricate scrolls and carvings echo the elaborate architectural details employed by Holt and his artisans in the David A. Barnes House. (Courtesy of Murfreesboro Historical Association.)

The contractor/builder of the 1825 Southall-Neal-Worrell House on Murfreesboro's Broad Street is unknown, but it was probably built using some black artisan labor. Typical of houses constructed close to river traffic, this house has a rear that faces the Meherrin River and walls that are 21 inches thick to repel possible cannon attack from pirates. (Courtesy Murfreesboro Historical Association.)

Plantation slaves crafted beds, cradles, cabinets, cupboards, and other pieces of furniture for plantation households. Some pieces were unusually fine but most found their way into the kitchen and other less formal rooms as every day utility pieces. (Courtesy the author.)

This barn and shed outside of Murfreesboro contain the classic overhang and steeped pitched roof symbolizing two African architectural characteristics in Hertford vernacular architecture. (Courtesy the author.)

In some county locales, small family settlements were dotted by family-constructed homes such as the ones found in Eley Town outside Murfreesboro. The home of Shirley Eley Parker (pictured) was built by her brother Zebulon Eley. He also built a Carolina Piedmont–style house for all his brothers and sisters in Eley Town and one for his brother Troy on Diamond Street in Murfreesboro that was destroyed in 2001. (Courtesy the author.)

Slave carpenter Drew Holloman is credited with building the James Newsome House (Wynnwood, c. 1830), and the 1832 William W. Mitchell House (pictured), both in the Ahoskie area. After the death of his owner, Holloman worked as a builder to provide an income for his widow and children. (Courtesy of Preservation North Carolina.)

Six
TROUBLED WATERS

Port villages such as Murfreesboro and Winton produced conditions that strained and undermined the regime of slavery. Slaves handled the bulk of the domestic drudgery, worked in shops and public houses, and built the streets, bridges, homes, churches, academies, and municipal buildings. The density of population and contact with sailors, free blacks, unlawful whites, and one another provided a forum for rebelling and discussion of rebellions, far and near. Combined with the threat of discontented village slaves was the very real dangers posed by camps of runaways (maroons) and the uncontrollable status of Hertford County's watermen and lumber camp slaves. Laws, increased patrols, and passes did little to calm the fears of Hertford County residents as news of rebellious slave plots reached the shores of the Chowan and Meherrin, year after year.

The busy docks of Murfreesboro and Winton heaved with commerce from the North and the West Indies. Ports were fair game for secret gatherings between local slaves, stevedores, and sailors. (Courtesy of North Carolina Collection.)

The Chowan River provided a watery highway for the numerous slave watermen who traveled between northeastern North Carolina and southeastern Virginia. The nature of their work dictated poor supervision and unlimited opportunities to travel, mingle, and engage in subversive activities. Slave teamsters also had ample opportunity to be exposed to anti-slavery discussions on their routes to and from market. (Courtesy of the author.)

The heavily forested, rural areas of Hertford County provided cover for slaves entering the area from Virginia. Slaves also held secret religious meetings under the cover of darkness in county forests. These "brush arbor" meetings permitted slaves to pray freely for their freedom and the end of slavery. (Courtesy of the author.)

Towns and villages were hotbeds of personal and local gossip that cut across the slave and free community. Authorities tried to legislate laws to temper the physical movement and gathering of free blacks and slaves but to little avail. Information passed unceasingly from black artisans, house slaves, and field hands to runaways hidden in nearby swamps. (Courtesy of Duke University.)

Runaway slaves formed permanent "maroon" communities in the neighboring Dismal Swamp and vicinity. Maroons raided plantations and were on speaking terms with some members of local slave communities. Some communities were destroyed but several provided shelter for deserting Confederate soldiers (Buffaloes) during the Civil War. Only after the war did most maroon communities cease to exist. (Courtesy of North Carolina Collection.)

The 1802 slave conspiracy in Bertie County had, at its core, activities connected to the Chowan River. The August conspiracy was allegedly hatched at the spring herring run and the plans of action were ferried to participants by slave watermen. The conspiracy was discovered and the region was alerted to the danger of numerous unsupervised blacks plying the waters of North Carolina and Virginia. (Courtesy of the author.)

Slave escapes, revolts, conspiracies, and rebellions inspired local slaves with hopes of freedom. The news from the West Indies and South America was always uplifting to slaves because these areas were nearly always under black assault. Authorities generally underestimated the impact far away places had on the lives of local blacks. Yet, following the war, West Indian place names such as Haiti and Diamond City were to be found in some black areas. (Courtesy of the author.)

There were 67 slaves (including two women) in the Bertie County conspiracy, who were captured and punished. Perhaps reflecting on the 1795 Bertie conspiracy where three slaves were charged and punished for plotting to lead 150 blacks into revolt, whites wasted no time in capturing the guilty parties. (Courtesy of the author.)

Slaves in Bertie, Washington, Perquimans, Chowan, Halifax, and other counties along the Roanoke and Chowan Rivers were captured in the 1802 plot, including Frank, who belonged to David Sumner of Hertford County. Most of the conspirators could read and write. The majority of the men were landlocked field hands who had obviously worked in concert with the watermen. (Courtesy of the author.)

67

Nat Turner's 1831 southeastern Virginia revolt threw the entire South into a panic. The Murfreesboro Militia responded first to the alarm and reportedly killed some 40 blacks in one day. The days following the revolt were so frenzied that two innocent Murfreesboro blacks were murdered. Nat Turner and his followers were captured and punished, but the fear generated by his revolt would fuel white imagination until the Civil War. (Courtesy of the author.)

Mary Coleman Freeman, a free black living in Windsor, Canada shared in an 1855 interview the abuse she and her family suffered in Hertford County following Nat Turner's revolt that persuaded them to flee to Canada. Freeman's father, a Revolutionary War veteran, harvested the family's crop and fled due to abuse from white people who owned no slaves. The group unlawfully searched for and threatened the family. (Courtesy of the author.)

Col. John H. Wheeler, a Murfreesboro native, lost his slaves in Philadelphia in route to New York. The slave woman, Jane Johnson and her two sons, were freed by abolitionists William Still and Passmore Williamson. Wheeler assured the two that Johnson did not wish to be free but she responded, "I am not freed, but I want my freedom—always wanted to be free! But he holds me." (Courtesy of North Carolina Collection.)

The Bondswoman's Narrative By Hannah Crafts—A Fugitive Slave Recently Escaped from North Carolina was edited and published in 2002 by Harvard's Henry Louis Gates Jr. Hannah Crafts, who was owned by Col. John H. Wheeler, is believed to have written the autobiographical narrative between 1853 and 1861. Gates asserts that Crafts's book is perhaps the first novel written by a black woman in America and the first novel written by a female fugitive slave. (Courtesy of *Roanoke Chowan News Herald*.)

Abolitionist John Brown believed that victory over slavery could only be won by a violent slave uprising. To this end, Brown and 18 men, including five former slaves (two from North Carolina), captured the Federal Arsenal at Harpers Ferry, Virginia (later West Virginia) in 1859. Brown and his fellow conspirators were captured and all but one were hanged. Their deaths were a prelude to the greater violence of the Civil War. (Courtesy of Library of Congress.)

As soon as word spread in Hertford County of the Civil War, many blacks in eastern North Carolina began to seek every opportunity to escape to Union lines. A party of 15 or 20 men, women, and children risked being shot by their masters, who fired upon them from the shores of the Chowan River, to reach Union forces at Roanoke Island. (Courtesy of Library of Congress.)

Slave brother and sister, Edith and Jacob, opted to remain with the Britt family who owned them, just outside of Murfreesboro. Jacob, a carpenter and mason, is credited with building the house and chimney, shown here, on the Britt-Phillips House between Ahoskie and Murfreesboro. (Courtesy of the author.)

Slaves Edith and Jacob are buried in the restored Britt Family Cemetery near Murfreesboro. The slaves' headstone was placed in the 1990s by Robert Britt, the last surviving family descendant, who spoke of the pair as being an integral part of the Britt family. The story of Edith and Jacob were told to him often as a child by his aunt Nellie Gray Britt. (Courtesy of the author.)

Throughout the Civil War, many slaves were pressed into the service of the Confederacy. Planters saw it as their duty to contribute the labor of their slaves to the Southern cause. Slaves served the Confederacy as teamsters, cooks, body servants, and in other unpaid non-combat areas. They played a large role as builders and probably supplied the skills and labor in the building of the CSS *Albemarle*. (Courtesy of the author.)

The CSS *Neuse* is pictured during construction in 1862, perhaps using some black artisans. There is no indication that blacks who were pressed into the Confederacy committed any acts of sabotage, although they did run away in large numbers. William D. Newsome, a free black and the founder of Murfreesboro's First Baptist Church, was a Confederate ambulance driver who turned himself in as a Confederate deserter near the end of the war. (Courtesy of the author.)

Issac Newsome was born a slave in Hertford County in 1832. He was 29 when the Civil War began and ran away and joined the Union Army. He returned to Hertford County at war's end and used his pension to purchase a farm with his brother Ephrim Slaughter. Newsome and his wife Della had two children, John and Eleanor. John became Hertford County's first black mailman in 1905 and Eleanor Newsome Mitchell became an educator and founder of the Robert Lee Vann High School in 1938. Newsome Grove Baptist Church near Ahoskie is named in honor of Civil War veteran, prominent citizen, and prosperous farmer Issac Newsome. (Courtesy of *Roanoke Chowan News Herald*.)

Sixty soldiers and sailors from Hertford County served with Union forces during the Civil War. Many African-American veterans faced extreme prejudice when they returned home, as did their wives and children in Union refugee camps. Corp. John Bizzell, Richard Weaver, Andrew Reynolds, James Manly, Miles Weaver, and Briant Manly of the Fourteenth United States Colored Heavy Artillery had their homes searched and their weapons and ammunition seized, and they reported beatings upon their return to Winton in 1866. They appealed to the North Carolina Freedmen's Bureau for restoration of their weapons. The prejudice against African-American Civil War veterans continued unabated as Confederate statues, monuments, and memorials appeared in Hertford County and every county in the South. Black units were not invited to march in veteran parades in Washington, D.C. beginning in the 1880s, and their contributions and military service for the preservation of America were systematically omitted from history books for almost a century. (Courtesy of Library of Congress.)

Parker David Robbins was born in 1834, a free black of Chowan Indian ancestry. A carpenter by trade, Robbins, a Bertie County native, owned a 102-acre farm. In 1863, he crossed the Chowan River and made his way to Norfolk, Virginia through Union lines and was enrolled as a sergeant major in the Second United States Colored Cavalry in 1864. He remained in the cavalry until his honorable discharge at Hampton, Virginia in 1866. He represented Bertie County at the State Constitutional Convention in 1867 and was elected to the state House of Representatives in 1868. In 1873, Robbins moved to Harrellsville in Hertford County and became postmaster in 1875. While still in Harrellsville, he patented a cotton cultivator in 1874 and in 1877, a saw-sharpening machine. In 1884 he married Elizabeth Collins from the Pleasant Plains community in Hertford County. By 1896, he was divorced and remarried to Bettie Florence Miller. To this union one child was born, Leo Parker Robbins in 1900. Robbins lived the last 39 years of his life in Hallsville and Magnolia, North Carolina, where he built two homes, operated a cotton gin and saw mill, and ran a self-made steamboat between Hallsville and Wilmington, North Carolina. Robbins died in 1917. (Courtesy of North Carolina Division Archives and History.)

Seven
CALVIN SCOTT BROWN

Not only were slaves were unlettered, but the vast majority of whites were, as well. With the end of the Civil War, northern religious organizations, in cooperation with the freedmen's bureau, organized hundreds of day and night schools. Classes were held in abandoned stables, homes, vacant buildings, and churches. Former slaves spent hours in the fields and then trudged to a makeshift school. While freedmen appreciated the dedication and devotion of white teachers, they usually preferred black teachers. To this end, hundreds of black teachers also came south as missionaries and teachers, much to the delight of former slaves. These teachers represented hope of the difference education could make in the lives of former slaves. White and black teachers, missionaries, former Union officers, and artisans banded together to establish schools that were tied to evolving black colleges in North Carolina. Calvin Scott Brown's work in Hertford County was the personification of educational groundwork that had been established for former slaves, their children, and their grandchildren in the hectic years of Reconstruction.

Dr. Calvin Scott Brown arrived in 1885 by boat to preach at Pleasant Plains Baptist Church. He was persuaded to establish a school, and Levi Brown Sr. of Winton donated and cleared the land with his sons before Dr. Brown returned to Raleigh. Brown returned to Winton and established Chowan Academy (1886–1893), which graduated its first class in 1890. The Brown home, above, became a Winton landmark. (Courtesy of North Carolina Division Archives and History.)

Dr. Brown, a native of Salisbury, North Carolina, took the task of administrating the school to heart and became a tireless worker on its behalf. Eventually he was elected president of the Lott-Cary Baptist Convention and president of the Educational and Missionary Convention of North Carolina. Brown's reputation in combination with the academy's strict curriculum insured that graduates were highly regarded as college candidates. (Courtesy of North Carolina Division Archives and History.)

Brown married Amaza Drummond of Lexington, Virginia on December 8, 1886. As Brown's wife, she was expected to serve the school in many different capacities. Teacher, nurse, dietician, laundress, and other responsibilities befell her as Brown traveled to secure funds for the school. Her most important role was that of helpmate to Brown and surrogate mother to their students. (Courtesy of North Carolina Division Archives and History.)

Reynolds Hall was completed in 1893, and due to contributions and fund-raising efforts on behalf of the school, the building was named in honor of Miss M.C. Reynolds of Chicago, Illinois. That same year, the school's name was changed to Waters Normal Institute in appreciation for the $8,000.00 donated to the building fund of Reynolds Hall by Horace Waters of New York. (Courtesy of North Carolina Division Archives and History.)

Dr. and Mrs. Brown, dark clothing center, posed with faculty, staff, and students for this 1890s photo taken at Waters Normal Institute. Students, parents, and community members took great pride in the school's reputation among educators throughout the South and eastern United States. (Courtesy of North Carolina Division Archives and History.)

Shown here are unidentified Waters Normal Institute graduates of 1898. Graduates were admonished to be ambassadors of the school's rigorous curriculum, Christian devotion, and high moral standards. (Courtesy of North Carolina Division Archives and History.)

Dr. Brown, third row standing center, posed with leaders from across North Carolina in honor of Tuskegee Institute president and national leader, Dr. Booker T. Washington and his 1910 visit to North Carolina Mutual Life Insurance Co. The group also visited Durham's newly established National Religious Training School and Chautauqua (North Carolina Central University), where this picture was taken. They were guests of Dr. James E. Shepherd, the school founder, seated second row, third left. (Courtesy of North Carolina Mutual Life Insurance Co.)

The 1893 name change ushered in an era witnessing the curriculum changes and teaching skills teachers in eastern North Carolina needed to teach African Americans. Normal Institutes or teaching schools were established to meet the ever-increasing need for black teachers and Waters graduates were highly sought after. Dr. Brown, seated, is pictured with the 1914 graduating class of Waters Normal Institute, many of whom probably became teachers. (Courtesy of North Carolina Division Archives and History.)

Reynolds Hall, featured at left in this postcard of the Waters Normal Institute campus, stood in tribute to the Chowan Educational Association (composed of area black churches) and the Chowan Sunday School Convention (composed of black schools of Hertford County). These organizations had raised large sums of money for its construction in 1893. The building was destroyed by fire in 1941. (Courtesy of Madge W. Hunter Collection.)

In the early 1920s, Morehouse Hall, a three-story brick structure was erected on the growing campus. By 1922, Waters Normal Institute, which had been operated by the West Roanoke Baptist Association, was nearly out of funds. Money was needed to pay teachers competitive salaries and to secure and maintain the proper equipment to meet state standards. Hertford County gained control of the school in 1923 and its name was changed to Waters Training School. (Courtesy of North Carolina Division Archives and History.)

The last building constructed during the tenure of Dr. Brown was the 1926 Brown Hall, shown at right. In 1937, the school was named Calvin Scott Brown High School in honor of Dr. Brown, who died the previous year. Today Brown Hall houses the Calvin Scott Brown Regional Cultural Arts Center and Museum, founded in 1986. (Courtesy of Madge Watford Hunter.)

Principal Hugh C. Freeland served as the only administrator of Calvin Scott High School beginning in 1937. Mr. Freeland became principal at the death of Dr. Brown and continued in that capacity until Hertford County closed the high school in 1970 and reopened it as Calvin Scott Brown Elementary School. The H.C. Freeland Building is named in his honor on the campus of Roanoke Chowan Community College. (Courtesy of the author.)

The Scroll was published by the students and staff of C.S. Brown High School in 1949, the only year of its publication. (Courtesy of the author.)

The faculty of C.S. Brown gather on the steps of Brown Hall in the late 1950s or 1960s. (Courtesy of Madge Watford Hunter.)

The C.S. Brown High School Marching Band pose on campus with band director Xavier Cason, far left, in the mid-1960s. (Courtesy of Dudley E. Flood.)

The C.S. Brown girls basketball team of the mid-1960s pose with coach and teacher Dudley E. Flood. (Courtesy of Dudley E. Flood.)

Rev. James A. Felton Sr. was a Hertford County teacher, Boy Scout troop leader, and community activist. He was also the founder and first president of the Calvin Scott Brown School Auditorium Restoration Association in the early 1980s. Reverend Felton was the first executive director of the Calvin Scott Brown Regional Cultural Arts Center and Museum. (Courtesy of Annie Vaughan Felton.)

This is the main classroom building at C.S. Brown High School as it appeared in 1970, the last year the school was classified as a high school by Hertford County. The building stands as a landmark to the achievements of Dr. Brown and the educational traditions he fostered beginning in 1886. (Courtesy of Madge W. Hunter.)

The Newport News Commuters Club purchased the C.S. Brown Gymnasium and Cafeteria in 2002 as a recreational facility for community children. The bleachers that once held cheering Brown students will soon provide seating for many of those students, now parents, as they cheer for their own children. (Courtesy of the author.)

Julia Whitaker, left, executive director of the C.S. Brown Regional Cultural Arts Center and Museum pose with Annie Vaughan Felton, a member of the board of directors, as they prepare for a 1990s exhibit at the museum. (Courtesy of *Roanoke Chowan News Herald*.)

Unidentified members of the C.S. Brown Varsity football team pose on the campus in the 1960s. (Courtesy of *Roanoke Chowan News Herald*.)

Eight
ROBERT LEE VANN

Robert Lee Vann, born to a former slave in Ahoskie, moved with his mother to Harrellsville when he was a baby. When Vann was 10, his mother married. His stepfather taught Vann to set steel traps in the swamp for small game, kill snakes, and plow with an ox. Vann learned to split rails, hoe cotton and corn, dig ditches, and cure tobacco. He was hired out to drive horses during the herring run, making sure that the windlass was turned to haul in the seine net. A.C. Booth, a black political appointee, made Vann a clerk in the Harrellsville Post Office where he earned $16, and with that money he entered Waters Normal Institute in Winton. He considered Dr. C.S. Brown a benefactor and great influence on his life. From Winton he went on to graduate from Virginia Union University in Richmond, Virginia. In Pittsburgh, Pennsylvania, Vann received his B.A. and law degrees from the University of Pittsburgh. In 1909, he became a lawyer, but by 1910 he had become involved in the formation of the Pittsburgh Courier Publishing Co., of which he eventually gained control. After 1912, Vann served as editor of the Pittsburgh Courier, *which rapidly developed into the most widely circulated African-American newspaper in America. Originally active in Republican politics, he was assistant to the city solicitor from 1917 to 1921. He became a democrat in 1933.*

Robert Lee Van (fifth row right, dark suit) attended the Conference of Black Editors and Publishers in Washington, D.C. in 1914. They met with President Wilson and top military leaders to pursue the cause of full black participation in World War I. (Courtesy of Library of Congress.)

This is the Harrellsville Post Office where, in the early 1900s, Vann worked as a postal clerk and earned $16. With that money, he entered Waters Normal Institute in Winton. He walked from Harrellsville to Winton as a day student and worked on campus to earn extra money for school. Vann credited Dr. C.S. Brown as being a benevolent influence on his life and Hertford County. (Courtesy of North Carolina Division Archives and History.)

Vann was instrumental in successfully switching the black vote to the democrats in the 1936 election. Vann also maintained a relentless voice against negative black images in mainstream radio, movies, newspapers, and literature. (Courtesy of Parker Brothers Publications.)

88

The *Courier* encouraged poor black tenant farmers of Hertford County and the South to leave for better opportunities in northern cities. Vann's editorials stressed the voting rights of northern blacks in addition to decent housing, jobs, and education for their children. (Courtesy of North Carolina Division Archives and History.)

African-American railroad porters and dining car employees distributed copies of the *Pittsburgh Courier* at the Ahoskie Depot (pictured here in the early 1930s) and throughout the South. Black railroad workers secretly replaced black watermen as the major source of news and political activities that swirled around the African-American community. (Courtesy of North Carolina Division Archives and History.)

Dr. Carter G. Woodson, the "Father of African-American History," followed Vann's example in the 1920s and established Associated Publishers—a company that published and circulated African-American history books that mainstream publishers would not print. In 1926, Woodson established "Negro History Week" and relied heavily upon the *Courier* and other black papers to get the message to black communities in Hertford County and the nation. (Courtesy of the author.)

Since the days of slavery, Hertford County had depended upon black labor in its lumber industries. These men are at the Brading Lumber Mill in Ahoskie of the 1920s. Vann pointed out that such jobs earned a man a living but did not enable him to properly educate his children and provide for his family. Instead of creating a future for his children, he was locking them into poverty. (Courtesy of North Carolina Division Archives and History.)

Black farmwomen and girls worked in the cannery in Ahoskie to supplement their farm incomes. Young black females also worked as domestics and laundresses to financially assist their families. By their mid-1930s, many of these women were mothers to children in their teens; many were grandmothers by their late 30s. Most were community-minded and devoted churchwomen. Southern writers and historians reinvented them, however, as "Mammy" because they were undereducated and poor. (Courtesy of North Carolina Division Archives and History.)

Eleanor Newsome Mitchell, daughter of Civil War veteran Issac Newsome, was instrumental in establishing state-supported Robert Lee Vann High School in 1938 Ahoskie. A noted educator, civic leader, and churchwoman, she often read the *Pittsburgh Courier* and other black newspapers to community members. Uneducated and undereducated blacks depended upon educated blacks like Mrs. Mitchell to keep them informed about paying taxes as well as legal and civic matters. (Courtesy of *Hertford County Herald*.)

H.D. Cooper, longtime principal of Robert Lee Vann High School, was essential in establishing the school in 1938 along with other concerned community members. Cooper insisted that the faculty, students, and staff of the school exemplify the spirit of industry, personal character, and community service personified by Vann. (Courtesy of Parker Brother Publishers.)

President Franklin D. Roosevelt made history when he organized his "Black Cabinet" to deal with affairs affecting black people. Vann, (front row, second left) was appointed to the black cabinet in 1938. In 1933, Vann was appointed special assistant United States attorney general by Roosevelt. In 1936 he relinquished his post to turn his full attention to the *Pittsburgh Courier*. (Courtesy of Library of Congress.)

During World War II, 16 liberty ships were named to honor African Americans of great achievements. The *SS Robert L. Vann* was built in the New England Shipyard, launched on October 10, 1943, and delivered to the Maritime Commission on October 26, 1943. The ship was sunk by a mine in the northeast Atlantic on March 1, 1945 with no loss of life. (Courtesy of Library of Congress.)

Robert Lee Vann High School graduated its last class in the early 1970s. The campus currently serves as a satellite campus of Shaw University through its degree granting C.A.P.E. program. (Courtesy of the author.)

Nine
EDUCATION AND RELIGION

The religious life of Hertford County African Americans originated in both traditional African religion and Anglo-Protestant Evangelicalism. Enslaved Africans transmitted styles of worship, funeral customs, religious rituals, and medicinal practices based on the religious traditions of West and Central Africa. Blind Sam, a product of Meherrin Baptist Church in Murfreesboro, was perhaps an evangelical preacher. Such black preachers probably preached in the high drama tradition of the black clergy and often enjoyed far-reaching popularity. Slaves broke the proscription against unsupervised or unauthorized meetings by holding their own services in well-hidden areas, usually referred to as bush arbors, brush arbors, or bush arbors. Although slaves attended church with their owners, many would steal away into the woods to pray and worship in their own fashion. Slave women soaked old quilts and rags in water before hanging them up in the belief that they muffled the sounds of the singing and praying slaves. Slaves also turned cast-iron pots upside down in the belief that the noise would be absorbed. Following emancipation, slaves and free blacks in Hertford County founded their own churches. The founding of Hertford County's African-American churches is forever tied to the establishment of educational institutions because early school and church buildings were usually the same.

Teacher and principal Amanda S. Cherry (rear left) stands with her students at Springfield School in the Harrellsville area in the 1930s. Two students are Marie Ward Gatling, (first row, second left) and Ethel Mae Ward Artis (white dress, standing left rear.) (Courtesy of Otelia Artis Perry.)

Rev. George Thomas (1893–1958) and Mrs. Luvenia B. Rouson (1895–1970) moved to Murfreesboro in 1924, one year after they were married. They served the Hertford County community as teachers, school administrators, church leaders, and political leaders. They instilled in their children Luvenia, Amphia, Katie, Samuel, William, and Wilbur Homer the virtues of strong Christian values—service to God and mankind. They transformed farm hands into enlightened masses. (Courtesy of Wilbur Homer Rouson.)

In 1924, Reverend Rouson became pastor of Murfreesboro First Baptist Church on Broad Street in the Boone's Hill section. The church was founded in 1866 by Rev. Washington L. Boone and was the first church organized by ex-slaves in the county. Rev. William Reid was the second pastor beginning in 1869 and purchased the Broad Street site where the church stood until the 1980s, when it was destroyed by fire. (Courtesy of Wilbur Homer Rouson.)

The Love and Charity Hall stood beside the church and was perhaps an earlier church building. It evolved into a fraternal meeting space and the site of Mrs. Rouson's kindergarten. Mrs. Rouson, rear center, and unidentified Murfreesboro kindergarten students pose in the sanctuary of the old First Baptist Church in the 1950s. Her kindergarten was one of the few places of preschools for black children in the South. A Hertford County teacher for 35 years, she continued to teach kindergarten for 10 years after her retirement. (Courtesy of Fred D. Eley Jr.)

Mrs. Rouson, right rear, and unidentified Murfreesboro kindergartners are pictured on the west side of the old First Baptist Church in 1955. (Courtesy of Wilbur Homer Rouson.)

Reverend Rouson is shown posing with Gertrude Lawrence (left) and Claudia Reid at a Murfreesboro First Baptist Church gathering in the 1950s. (Courtesy of Wilbur Homer Rouson.)

Riverview Elementary School PTA members pose at a 1950s luncheon. (Courtesy of Constance Marie Boyce.)

For many years the only shoe repair shop in Murfreesboro was owned by Tommy Boone and stood on the corner of East Main and Boyette Streets. Boone is pictured here with his wife Susie, a Hertford County teacher, their daughter, Tommisene (far left), and Bettie Jean (far right) in the 1950s. (Courtesy of Constance Marie Boyce.)

May Queen Tommisene Boone (sitting center) is pictured with her May Court at Riverview Elementary School mid-1950s. (Courtesy of Constance Marie Boyce.)

From left to right, Riverview Elementary School principal A.R. Bowe, Gertrude Strayhorn, Claudia Reid, and Eugene Reid are at a 1950s ceremony in honor of Mrs. Reid. (Courtesy of Constance Marie Boyce.)

Geneva Bowe, a Hertford County teacher supervisor of African-American schools, is shown with her daughter Joyce on remnants of a 1960s May Day Court at Riverview Elementary School. (Courtesy of Constance Marie Boyce.)

The faculty and staff of Riverview Elementary School pose in the 1960s. From left to right are (front row) Annie Simmons, Bernice Flood, Gertrude Lawrence, Odell Eley, Geneva Bowe (supervisor), Claudia Reid, A.R. Bowe (principal), Mrs. ? Manley, and Gertrude Fennell; (middle row) Wesley Williams, Virginia Lawrence, Eunice Holloman, Mrs. ? Jenkins, Rebecca Williams, Ida Scott, Gertrude Strayhorn, Flossie Vinson, Agnes Manley, and Dudley Flood; (back row) Susie Deloatch, Louise Fleetwood, Cora Lee, Gladys King, Audrey Williams, Mrs. ? Mitchell, Mrs. ? Porter, Mrs. ? Ruffin, Susie Boone, and Gertrude Purdy. (Courtesy of Constance Marie Boyce.)

H.C. Freeland, seventh from the left, posed with Hertford County educators at a banquet. (Courtesy of Constance Marie Boyce.)

101

Friends, teachers, and church members pose at a luncheon. From left to right are Bettie Jean Boone (sitting), Beatrice Jenkins, Eugene Reid, Vida Langston, Louise Fleetwood, Virginia Lawrence, Odell Eley, Agnes Manley, Olivia Gibons, Susie Boone, Rebecca Williams, and Geneva Bowe. (Courtesy of Constance Marie Boyce.)

These are the Mill Neck Rosenwald School 1959 Boy Scout and Cub Scout troops. Troop members and leaders from 1959 are, from left to right, Walter Scott, James Hudson (killed in Vietnam), Calvin Everett, ? Britt, ? Banks, T. Hudson, ? Pope (cub scout) and Mark Hoskie (cub scout); (second row) Rev. H.L. Mitchell, Calvin Everett, W.T. Scott, and Rev. James A. Felton, troop organizer and leader. (Courtesy of Annie Vaughan Felton.)

Katie A. Hart is the founder and operator of the only independent African-American public library in the United States. She loaded the trunk of her car with books and newspapers and drove to the outmost regions of the county to provide reading materials. She secured funds for the first Southern bookmobile and organized the county's first P.T.A. She was also the first black supervisor of classroom instruction in Hertford County. (Courtesy of Parker Brother Publishers.)

Alice Jane Eley (dark glasses) and unidentified area V.I.S.T.A. volunteers pose at New Ahoskie Baptist Church in 1968. Recruited by Rev. James A. Felton and trained as part-time students at Shaw University in Raleigh, Shaw University's V.I.S.T.A. volunteers worked as community organizers and civil rights activists throughout North Carolina. For her outstanding work at Shaw University, Eley was awarded The Minnie Fuller Memorial Scholarship and graduated from North Carolina Central University. (Courtesy of Annie Vaughan Felton.)

Katie A. Hart was successful in getting Rosenwald Schools, such as Millneck in Como, constructed in the county. The schools were funded in part by a fund established by Julius Rosenwald, president of Sears, Roebuck, and Co. and conceived by Tuskegee Institute President Booker T. Washington in the 1910s. Blacks had to match donated funds before a school could be built, usually using community builders and donated materials. (Courtesy of the author.)

The Mapleton community was served by the Mapleton School, built in the 1920s, until the students were transferred to Riverview Elementary School in Murfreesboro. (Courtesy of the author.)

Vaughantown School was built between 1918 and 1919 and served the Vaughantown community south of Murfreesboro until the students were transferred to Riverview Elementary School. (Courtesy of the author.)

This school, located in the Menola community and built in the mid-1920s, serves today as a community and church hall for Menola First Baptist Church. (Courtesy of the author.)

The Pleasant Plains School was constructed in 1920 and continues to serve the community and Pleasant Plains Baptist Church. (Courtesy of the author.)

Mapleton's Parker Grove Baptist Church serves the Mapleton, Murfreesboro, and Eley Town communities. (Courtesy of the author.)

Nebo Baptist Church of Murfreesboro has been on Highway 258 for many years. (Courtesy of the author.)

The First Baptist Church of Winton displays the architectural characteristics of our modern age—the wheelchair ramp. Nearly all the county's churches are accessible for the handicapped. (Courtesy of the author.)

Mount Moriah Baptist Church is located in the Winton vicinity. The old Cotton Rosenwald School is located near the church but is nearly covered by brush. (Courtesy of the author.)

The land for Newsome Grove Baptist Church was donated by Civil War veteran Issac Newsome in Ahoskie. (Courtesy of the author.)

New Bethany Baptist Church in Harrellsville is an inspirational and beautiful red brick structure in the midst of lush countryside greenery. (Courtesy of the author.)

The Mill Neck Baptist Church stands across the road from the Millneck Rosenwald School. (Courtesy of the author.)

According to Mrs. Odell Cowper Eley of Murfreesboro, her grandparents, Issac Jefferson and Roxie Sweat Cowper, donated the land on which the first Mt. Sinai Church in Como was built. They also donated two acres of land adjoining the church for the construction of the Mt. Sinai Rosenwald School in 1925. (Courtesy of the author.)

In 1868, the county gave one acre of land on which a one-room log structure was built to educate the black children of the Catherine Creek community. In 1903, a new building was erected. Under the leadership of Mary E. Sills and others, the new building was moved to the site of Robert L. Vann High School. The old school site was sold to New Ahoskie Baptist Church (pictured). (Courtesy of the author.)

Phillipi Baptist Church is located in Cofield, one of only a handful of all-black incorporated townships in America. Reportedly, it was settled by free blacks and several Meherrin families. Cofield was originally called Sally Archer's Crossroads, but the name was changed in the early 1900s upon the establishment of the post office. (Courtesy of the author.)

The cross on the steeple of Menola Baptist Church is a quiet symbol of faith in the rural countryside outside of Murfreesboro. (Courtesy of the author.)

The double towers of Murfreesboro's New Haven Baptist Church are touches of dignity in a rural agricultural setting. (Courtesy of the author.)

In 1865 Rev. Lemuel Boone organized the East Roanoke Baptist Association in the Haven Creek Baptist Church on Roanoke Island. The following year he is credited with organizing what became known as the First Baptist Church of Murfreesboro. Boone was the first pastor of the church and was influential in the growth and development of Como's Mill Neck Baptist Church. A North Carolina highway marker serves as a guide to his grave. (Courtesy of the author.)

Ten
PARTING SHOTS

Enslaved and free, African-American pioneers came to Hertford County to work. The county's lumber, maritime, agriculture, naval stores, and manufacturing industries relied heavily upon black laborers. Similar to European settlers, they created a world that combined their Old World heritage and their New World identities. In this land of the Meherrin, African-Americans served as soldiers, built county architectural landmarks, worked the land, and fought for civil rights. They worked as teachers, domestics, nurses, lawyers, doctors, inventors, and slaves. Today, they own businesses, belong to fraternal orders, and are poets, veterans, police officers, sheriffs and deputies, cooks, midwives, and fishermen. There is no one word to define them. They are as varied as the deeds that represent the hallmarks of their lives.

Harrellsville Savings Club pose in the 1960s following their meeting. From left to right are (front row) Mack Downing, George Cherry (husband of principal Amanda S. Cherry), John Manley Sr., W.E. Beamon, Lawrence Mizelle, and Ben Slaughter; (second row) Raleigh Harrell, Lattice Askew Sr., Elton Twine, James Harrell, Delmar Harrell, and Zebedee Artis Sr. (Courtesy of Otelia Artis Perry.)

113

The dedication of the Rochelle Vann Farm House in 2001 at Elizabeth City State University is the latest in a lifetime of achievements for the Winton native. A former student of Simon Haley and a 1947 graduate of ECSU, Professor Vann taught at C.S. Brown for 21 years before joining Elizabeth City's history faculty. He was named ECSU Distinguished Teacher of the Year (1972 and 1974) and Professor Emeritus. (Courtesy of *Roanoke Chowan News Herald*.)

Jacob Ruffin Jr., left, is sworn in as a member of the Murfreesboro City Council. The long-time councilman was the first African American to be elected to the council. (Courtesy of *Roanoke Chowan News Herald*.)

114

After the Civil War, one of the few business choices open to African Americans was that of the funeral home. Blacks determined that they could direct funeral services that met the cultural needs and dignity of emotion of the African-American client. Reynolds Funeral Home of Ahoskie, shown here, was established in 1926 as an outgrowth of Hertford County Undertakers Union, established in Winton in 1916 by a union of shareholders from Hertford, Bertie, Northampton, and Gates Counties. The 1890s heralded the rise of black businesses in North Carolina due in part to the leadership of Booker T. Washington and North Carolina Mutual Life Insurance Co. in Durham. In spite of 1896 Jim Crow laws, blacks progressed in business and education. (Courtesy of the author.)

Howard J. Hunter Sr. established Hunter's Funeral Home in Ahoskie in 1949. Today, Hunter's Funeral Home has branch establishments in several locations in the Albemarle region in addition to its main headquarters in Ahoskie. These businesses are operated by Hunter's sons and grandsons. Hunter was very active in Ahoskie and Hertford County civic affairs. He was a chair of Hertford County Board of Education, a member of Hobson R. Reynolds Elks National Shrine, and a member of the North Carolina Human Relations Committee, and he helped establish Ahoskie's first black Boy Scout troop in 1954. (Courtesy of the author.)

Wilbur Homer Rouson, a Chicago artist, poses at the opening of his exhibit in Winton's C.S. Brown Regional Cultural Arts Center and Museum with, from left to right, Julia Whitaker, Brown executive director; Agatha Lewis, Brown museum volunteer; and Annie Vaughan Felton, member of the board of directors. Rouson is a graduate of C.S. Brown High School and a Murfreesboro native. (Courtesy of Wilbur Homer Rouson.)

Nellie G. Melton, the former mayor of Cofield (1979–1982) is perhaps the only mother whose daughter also served as mayor in North Carolina. Melton's daughter, Julia Whitaker, was also elected mayor of Cofield in the late 1980s. (Courtesy of Julia Whitaker.)

Lillie Owens White, center, was instrumental in organizing the C.S. Brown All-School Reunion in 1997. Former C.S. Brown Tigers from across the nation attended the two-day affair held in Winton. (Courtesy of *Roanoke Chowan News Herald*.)

Will Edgar Wood posed in 1972 at his 100th birthday celebration. Wood, a record-setting carp fisherman, was a Murfreesboro farmer. His daughter, Minnie Perkins, left, worked in the Murfreesboro area for well over 40 years as a midwife with Doctors Futrell, McLean, and Barnhill. (Courtesy of Iris R. Eley.)

Modern farm equipment has proven to be labor saving for the farmer. George Fillmore Connington Whitaker (1856–1938) was born a slave in Enfield and settled in Murfreesboro in 1892 as a roofer and shingler. About 1895, he produced several new peanut-harvesting machines. Whitaker refused a partnership offer in 1899 and was surprised when Fenton Ferguson and Jesse T. Benthall of Murfreesboro patented their horse-driven peanut picker. (Courtesy of the author.)

Known as the Poet Laureate of Hertford County, Trinette Burford Vaughan is often requested to recite her poetry at special ceremonies. The Winton native is a graduate of C.S. Brown High School. (Courtesy of the author.)

Murfreesboro native Herbert Claude Eley posed with actor Andy Griffith on the set of *Matlock* between takes. A dramatics arts and theatre graduate of North Carolina Central University and the Ohio State University, Eley acted in several productions filmed in and around Wilmington, North Carolina studios. (Courtesy of the author.)

Deacon and Mrs. Garfield Stiff personified Christian stewardship, civic duty, and personal integrity to the Murfreesboro community. The Stiffs were faithful servants of the Murfreesboro First Baptist Church. (Courtesy of Lee Stiff.)

Dr. Lee Stiff is an internationally regarded mathematician and author on the faculty of North Carolina State University. Married to the former Renee Flood of Winton, Dr. and Mrs. Stiff are the parents of two daughters. High school sweethearts, the Floods are both graduates of C. S. Brown High School and The University of North Carolina, Chapel Hill. (Courtesy of Lee Stiff.)

Dr. Dudley E. Flood is a Winton native, teacher, principal, former assistant and associate state superintendent of the North Carolina Department of Public Instruction, and executive director of the North Carolina Association of School Administrators. He is currently a member of the UNC Board of Governors. Flood and his wife Barbara live in Raleigh. (Courtesy of *Roanoke Chowan News Herald*.)

Elizabeth Snead and President Jerry Jackson of Chowan College pose together as she is honored for 34 years of service to the college. Snead began working at Chowan College in 1945. (Courtesy of *Roanoke Chowan News Herald*.)

Lillie Mae Holley (below, right), who for most of her adult life was employed as a domestic, remembers the slave houses that once stood where the Murfreesboro Municipal Building now stands. A soft-spoken woman who is just over 100 years old, she lived in one of the houses for a number of years. Her daughter, Dora Holley Lassiter, also remembers living in the Broad Street house as a child. (Courtesy of Dora Holley Lassiter.)

121

Dr. Roy D. Flood, a Winton native and C.S. Brown graduate, became Murfreesboro's first African-American physician in the 1960s. He and his wife Yvonne are the parents of two sons. (Courtesy of Wilbur Homer Rouson.)

The United States Armed Forces has been a factor in the lives of Hertford County blacks since the days of the American Revolution. Pfc. April D. Eley poses in 1977 and represents hundreds of county military soldiers. Following her military service, Eley became a civil service employee in Washington, D.C. Today she is a retired career FBI and CIA employee. (Courtesy of the author.)

These men hauling in a seine net on the Meherrin River four miles east of Murfreesboro are carrying on a fishing tradition that flows beyond slavery, all the way back to the rivers of West Africa. The "Herring Run" remains a special springtime celebration in Hertford County. Although the schools of fish are severely depleted, locals still harbor the hope of full nets between March and June. (Courtesy of *Roanoke Chowan News Herald*.)

Rev. James A. and Mrs. Annie Vaughan Felton stand with an unidentified guest (left) in Felton Square in the Felton Family Center in Rich Square, North Carolina in the 1980s. Reverend Felton received many citations for his civic minded projects in the Albemarle communities of Hertford, Gates, Northampton, and Bertie Counties. The Feltons are the parents of six children. (Courtesy of Annie Vaughan Felton.)

The lone gatehouse is all that remains visible from Chowan Beach Road near Winton of the highly popular beach situated on the Chowan River. The beach and amusement park was the only such facility open to Albemarle area blacks during segregation. The "Disney World" of Hertford County provided wholesome fun for church groups, teens, and families. Food and beverages were sold but most groups packed a picnic basket, because going to the "beach" was an all day affair. (Courtesy of the author.)

African-American fraternal orders and mutual benefit societies emerged from a rich underground of "invisible" institutions and folk ways that slaves had created in their plantation communities. They also resembled mutual benefit societies among European immigrants. The first fraternal order in Hertford County was the Order of Brothers and Sisters of Love and Charity. In the early 1930s, others included the Odd Fellows, Eastern Star, Elks (shrine pictured), Masons, and Tents. (Courtesy of the author.)

The marching band of Hertford County High School in Ahoskie perform during an annual county Christmas parade. Band members practice long hours before and after school to insure a smooth performance at each of their engagements. (Courtesy of *Roanoke Chowan News Herald*.)

Alice Eley Jones, a Murfreesboro historian, and her guests pose at a private tour of Durham's Historic Stagville in the mid-1990s following the Dr. Earlie E. Thorpe Memorial Lecture, which Jones established at the site. In honor of their visit, Jones performed a traditional West African libation ceremony. From left to right are Dr. John Hope Franklin (guest lecturer), Mrs. Theresa B. Hall (Durham), Alice Eley Jones, and Dr. John Whittington Franklin. (Courtesy of the author.)

Former Civil Rights leader Rosa Parks is pictured with Murfreesboro historian Alice Eley Jones at Historic Stagville in 1996 following Jones's lecture on her 1991 research for the doll Addy Walker and the Pleasant Company's publication "Meet Addy." Mrs. Parks delighted in Jones's discussion of her native Hertford County and the escape route she researched, which took the main character down the Chowan River, through the Albemarle Sound, and out to sea. (Courtesy of the author.)

The Atlantic District Fair in Ahoskie is one of Hertford County's oldest grand events. The fair adds important dollars to the county's economy as thousands of fairgoers from southeastern Virginia and northeastern North Carolina attend annually. Once past the ticket booth, the midway awaits with its seemingly endless food courts, games, rides, arts and crafts displays, entertainment, animal judging, and harness racing. (Courtesy of Roanoke *Chowan News Herald*.)

Robert Vinson, shown here at Riverside Manufacturing Co. in Murfreesboro, managed the River Street Ballpark for many years. Segregated ballparks and ball games were major entertainment for blacks in Hertford County. Black ball games were a cultural expression of foods, clothing, and playing styles. Equally as important as the game and the skill of the athletes was the community cohesiveness created at these social gatherings. (Courtesy of *Roanoke Chowan News Herald*.)

An unidentified student recites during an annual Black History Month observance. February was chosen in 1926 by Dr. Carter G. Woodson as the official month for the observance because Abraham Lincoln and Frederick Douglass were both born in that month. Black History Month celebrations have deservedly remained an important part of the events scheduled yearly in Hertford County Schools for parents, teachers, and community members. (Courtesy of *Roanoke Chowan News Herald*.)

The now-demolished auditorium in the old Riverview Elementary School was the site of school and community programs. Traditionally programs opened with the audience standing and singing the *Negro National Anthem* followed by the *National Anthem*. Riverview School also showed movies in the auditorium for a dime, which helped young students avoid the dangers of climbing the perilously steep outside steps to the balcony of the local theatre. (Courtesy of *Roanoke Chowan News Herald*.)

Next to the mythical Mammy, Southern writers and historians wove tales of root doctors such as Dr. Jim Jordon of Como. For decades, people found their way to Jordon's Corner on Highway 258 North only to discover that Como was also the home of Richard Gatling, inventor of the Gatling Gun and an early flying machine that Jordon reportedly witnessed. (Courtesy of the author.)